The Broken Leaf

The Broken Leaf

砕かれた葉

Meditations on Art, Life, and Faith in Japan

ROGER W. LOWTHER

RESOURCE *Publications* · Eugene, Oregon

THE BROKEN LEAF
Meditations on Art, Life, and Faith in Japan

Unless otherwise noted, all Scriptures are taken from The Holy Bible, New International Version, copyright © 1973, 1978, 1984 by the International Bible Society. Used by permission of Zondervan Publishing House. The "NIV" and "New International Version" trademarks are registered in the United States Patent and Trademark Office by International Bible Society.

Scripture quotations marked ESV are taken from The Holy Bible, English Standard Version, copyright © 2001 by Crossway, a publishing ministry of Good News Publishers. Used by permission. All rights reserved.

Scripture quotations marked KJV are taken from The Authorized (King James) Version, copyright © Cambridge University Press. All rights reserved.

Community Arts Tokyo
Tokyo, Japan
www.communityarts.jp
info@communityarts.jp

Resource Publications
An Imprint of Wipf and Stock Publishers
199 W. 8th Ave., Suite 3
Eugene, OR 97401

www.wipfandstock.com

PAPERBACK ISBN: 978-1-7252-5113-7
HARDCOVER ISBN: 978-1-7252-5114-4
EBOOK ISBN: 978-1-7252-5115-1

Manufactured in the U.S.A. 04/18/19

To my artist community in Japan

Thank you for your friendship. You have taught me so much about myself and this world. Without you, the content of this little book would certainly not have been possible.

Contents

Preface

EVERY MONTH IN TOKYO, a small group of people gather to discuss a work of art, what it has to do with our lives, and what it shows us about the Christian faith in a Japanese context. We call these gatherings, appropriately, "Art, Life, Faith." The themes are always different, given by artists who are experts in their fields: musicians, dancers, painters, photographers, and the like. We deliberately created a space where these conversations could happen, and consequently opened ourselves to (sometimes) months of further conversations, emails, and texts. The pages of this book are an attempt to record some of these conversations.

It is a great honor for me to now call Tokyo home. The exchanging of ideas here over the years has not only changed me but how I view the world. These "Art, Life, Faith" conversations have been a training ground for everyone involved. As many of us have struggled together as a community of faith with our art, we have taught and encouraged each other in ways impossible by any other means. And no one is more rewarded by these discoveries than I am! I am always excited and energized by seeing images of God and parallels with the Bible embedded in the Japanese culture in ways I never imagined possible. It is my hope that readers too can be drawn into these conversations and share in the excitement.

The theme of this book comes from a 2016 conference we held in Tokyo entitled, "BROKEN—In A Hurting World," but the contents herein reach far beyond that conference to a longer and ongoing discovery process about God and ourselves. It is my sincere hope that these words will spark your own imaginations to see

yourself, the world around you, and the God of the Bible in fresh
and exciting ways.

TOKYO, JAPAN
OCTOBER 2019
ROGER W. LOWTHER
FOUNDER & DIRECTOR, COMMUNITY ARTS TOKYO

Introduction

IMAGINE FOR A MOMENT you are visiting a home in a foreign country. After walking through the door, you are immediately perplexed about what to do next. Should you take off your shoes or leave them on? Should you shake hands with your host? Or hug or kiss them? Or simply give a respectful bow? Should you walk further inside or wait in the doorway? How will you know what to expect if you do not even understand what is being said?

Cross-cultural communication is complicated, not just because of language. Nonverbal communication and even silence can add further layers of misunderstanding. We have to ask the question: Is it even possible to clearly and accurately communicate with people from other cultures?

Differences in language and culture have had a huge impact on the history of missions in Japan. Francis Xavier, one of the first foreign missionaries to Japan, reported to the Pope that "the Japanese language was designed by the devil, specifically to prevent the spread of Christianity in Japan." As ridiculous (and infuriatingly insensitive!) as this comment is, anyone who has studied language and culture for any length of time can at least identify with his frustration.

You cannot learn a language only by asking, "How do you say this?" More often than not, the answer will be, "We don't say that." Fluency is not achieved through translation. You will just end up sounding like a foreigner, and people will not be exactly sure what you mean. Language can only be learned by listening, observing, and interacting. Communication is learned in community.

If this is true with language, how much more true must it be in sharing the message of the Bible! Just as the person of Christ demands a relationship, the gospel must be shared relationally. This sharing flows in both directions, where careful listening and responding is needed between both parties. Christians must continually ask in any cultural context: What does the gospel look like, sound like, taste like, smell like, and feel like in this time and place?

When the twentieth-century artist Sadao Watanabe encountered Christianity, he considered it a cultural experience rather than a spiritual one. He writes,

> "In the beginning, I had a negative reaction to Christianity. The atmosphere was full of the 'smell of butter,' so foreign to ordinary Japanese."[1]

Dairy, nonexistent in Japan before foreigners arrived in the late 1800s, had nothing to do with Japanese culture. It had a strong and unpleasant odor. Even today in Japan, the "smell of butter" is a common pejorative expression. Like Watanabe, many Japanese conflate Christianity with Western culture, and many foreigners fall into this same trap.

One of Japan's most famous pastors, Kanzo Uchimura, called for the removal of that foreign flavor and smell from churches almost a hundred years ago.

> "Where are missionaries who are broad enough and deep enough and courageous enough to work with us to make Japanese Christians and establish Japanese Christianity? Such missionaries may come to Japan in any number and may stay as long as they wish. The country will welcome them as God's messengers, and will love them and honor them and revere them as its teachers and benefactors. Oh, where are they?"[2]

God is not new to Japan. He was in Japan before the first missionary set foot here. So how can we see the God of the Bible clearly as he exists in this culture with all of its unique beauty? How can we

1. Takanaka, *God Is Rice*, 6.
2. Uchimura, "Japanese Christianity."

see, hear, taste, smell, and touch God in a truly Japanese context? Mitsuo Fukuda writes,

> "God has decided to bless the universal church through a uniquely Japanese way of living out the gospel and understanding the church. God's mountain (the biblical data) needs to be drilled not only in a Western mine shaft (Western cultural perspective), but also in Japanese mine shafts and the six thousand or more other cultural mine shafts."[3]

Let's dig in those Japanese mine shafts and discover what treasures we may find together!

3. Fukuda, *Developing A Contextualized Church*, 144.

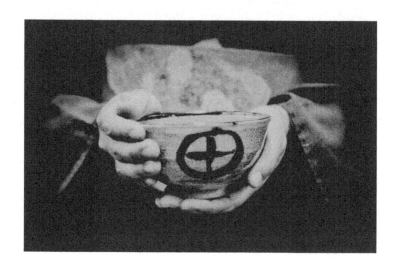

Chawan (2017)
Tim Mills

Meditation 1

The Broken Leaf

The Lord is close to the brokenhearted and saves those who are crushed in spirit.

—PSALM 34:18

Daddy, fix it!

How often I hear these words from my four small boys. Something . . . somewhere . . . *always* seems to be broken. Not just our bikes and our toys . . . but our homes . . . and our hearts too.

I will always carry around with me the pain and suffering of the people I worked with after the 2011 Great East Japan Earthquake. One woman told me (I never did find out her name) how she lost her whole family in the tsunami, including all three of her children, ages 8, 10, and 13, as they came home from school. "I'm so sorry," I mumbled weakly. Why did she lose her family while mine lived? It all seemed so arbitrary.

How do we respond to all the brokenness in this world?[1] Fighting, bombing, refugee crises, shooting in schools, terrorism . . . Day after day, we see and hear of new atrocities.

1. The Japanese language is particularly attuned to the language of brokenness, including the aesthetics of *mono no aware* and *wabi sabi*, which have no

After making my way from an underground subway halted by the earthquake in downtown Tokyo on March 11, 2011, I joined the masses standing in the streets Hundreds of digital screens played the horrific scene, magnifying the effect. Town after town was being wiped away live before our eyes by a wave of terrifying proportions on the northern coast of Japan.

Can a wounded and violent world truly be 'fixed'? Is there a path that leads to healing and to peace? I believe Japanese art quietly whispers of a way forward.

Shōtoku Taishi[2]—the famous leader from the seventh century who first called Japan the 'Land of the Rising Sun'—wrote, "Sickness is saved by sickness."[3] Brokenness is saved by brokenness, and wounds are healed by wounds. From ancient to modern Japan, we find the idea that the path to healing and redemption leads not around suffering, but right through the worst of it.

I think of redemptive brokenness shown in the art of *kintsugi* pottery, where veins of gold mend a broken bowl into something far more valuable than the original object. I think of *nihonga* painting, where the act of crushing minerals into powder brings out the shimmering and brilliance of the colors. I think of Japanese folk songs like *Sakura Sakura* ("Cherry Blossoms"), *Kōjō no Tsuki* ("Moon Over the Ruined Castle"), and *Tōryanse* ("The Crossing"), where inherent dissonance in the Japanese modes communicates a melancholic beauty that moves people to tears.[4]

Beauty in brokenness is an intrinsic characteristic of Japanese poetry, literature, flower arranging, *sumie* painting, rock gardens,

English equivalent. There are many ways to say 'broken' in Japanese that are simply translated 'broken' in English. These concepts are explored further in the Japanese edition of this book.

2. Prince Shōtoku (574–622 AD) was not just the son of the emperor and a great leader but was also regarded as the first Japanese writer.

3. Kitamori, *Theology of the Pain of God*, 26. Kitamori quotes Prince Shōtoku's classic *An Interpretation of the Yuimakyo*, which elaborates on the story of a Buddhist priest who makes himself sick in order to help people see their own sickness and need for healing.

4. The Japanese IN scale, the foundation of most Japanese folk songs, is made from two fourths at the most dissonant interval possible, a half-step apart.

and more. We recognize this aesthetic throughout nature—in the wilting of a flower, the shimmering of a fragile dewdrop, the melting of a snowflake, and the fall of a cherry blossom.

However, it is in the art of tea, the art most closely associated with the aesthetic of Japan, that I find the fullest expression of brokenness, beauty, and healing.

Tea. Why tea?

When I first moved to Japan, I did not understand why there were so many kinds of tea: green tea, black tea, barley tea, oolong tea, jasmine tea, crushed *matcha* tea, roasted *hojicha* tea, herbal tea, milk tea, and so many others. The Japanese word for absurd, *mucha*, literally means, 'without tea.' It's as if to say, "A day without tea? Don't be absurd!" The word for the common color brown is *chairo*—'tea-colored.' No other beverage gets this honor!

I grew up near Boston, Massachusetts, famous for the Boston Tea Party of 1773. An entire shipment of tea was destroyed in Boston Harbor to protest certain British taxes. This symbolic act galvanized colonists into action, escalating into the American Revolution and, eventually, independence. Residents of my hometown of Lexington burned every leaf of tea in their cupboards on the Lexington Battle Green, a name earned from the fighting that erupted there with British troops less than two years later. Tea culture in Boston never recovered, and coffee became the preferred drink of the United States.[5]

I did not learn about the mystery of tea until I moved to Japan. So simple, just hot water and broken leaf, yet so profound! For the aroma and flavor of tea to come out, the leaf must be 'broken'. The 'broken leaf' of tea reveals a mysterious relationship between brokenness and beauty.

In its origins, tea was a medicine. Even today, people drink tea (not coffee!) when not feeling well. In the late 1500s, Sen no Rikyu

5. Politically, patriotism in America continues to be linked in some way to coffee, not tea. The 'Tea Party Movement' was formed in the Republican Party as a patriotic political stance.

perfected the Japanese art of tea, developing the symbolism in the tea ceremony to emphasize brokenness in man and this world. He presented it as a way to heal in community through the gathering of a few in the small confines of a tea cottage.

I saw an exhibit of Rikyu's tea utensils at the Tokyo National Museum in Ueno Park. There was a hand-molded black *Raku* tea bowl, a bamboo flower vase to hold cut 'broken' flowers, and a large jug to hold water for the kettle.[6] All the utensils were rough and unevenly shaped to reflect the tangible brokenness we find in nature.

Raku is characteristically formed by hand, not with a spinning wheel, giving pieces their characteristic rough and uneven shapes. The bowls are then fired in straw, leaving burn marks, and cooled quickly, leaving cracking and unpredictable colors in the glaze.

To my surprise, the water jug had a huge vertical crack down the side, not from 400 years of age, but rather through a natural process of drying the clay. Only careful glazing prevented the jug from leaking water.

Rikyu's message was clear. Brokenness itself is important. Broken utensils symbolize and acknowledge our weakness, and Rikyu proposed that this was the necessary step towards healing and peace.

Rikyu lived during the Sengoku Period, one of the most tumultuous times in Japanese history. Military leaders fought for power and wealth. Rikyu's art was, in part, a response to the 'boiling water' of violence in the world around him. Eventually, he was cruelly subjected to the very violence he worked so hard to end. At the age of seventy, Rikyu was ordered by the warlord Toyotomi Hideyoshi to commit *seppuku* (ritual suicide) in his tea room of healing and peace.[7]

6. Each of these objects has a name. The tea bowl is called *Amadera*. The bamboo vase is *Onjoji*. The large cracked water jug is known as *Shiba no Iori*.

7. Some commentators suggest that the poem Rikyu wrote just before his death commends the path of self-sacrifice as the only way to healing and peace.

My wife and I named our second son Eastin Athelas, which means 'healing in the East'. The name Athelas is taken from J.R.R. Tolkien's trilogy *The Lord of the Rings*.

> *When the Black Breath blows*
> *And death's shadow grows*
> *And all lights pass,*
> *Come athelas! Come athelas!*
> *Life to the dying*
> *In the king's hand lying!*[8]

In the hands of the king in the story, the brokenness of the athelas leaf leads to healing and not disintegration. In the hands of the King of all kings, brokenness leads to unforeseen hope and redemption.

The book of Revelation tells of just such a leaf in heaven.

> "On each side of the river stood the tree of life . . . and the leaves of the tree are for the healing of the nations. No longer will there be any curse." (Revelation 22:2–3)

What kind of tree is this? Is it perhaps a tea tree? Is it possible that we can make tea from the leaves of the tree of life in heaven? What would it taste like? What kind of aroma, and flavor, and color comes from these broken leaves, forever reminding us of the great sacrifice of Jesus?

The way of brokenness is the way forward. The scalding violence of the world is answered with the scalding violence of the cross. A broken world is healed by a broken Christ on a broken tree. The broken tea leaves that bring healing point to Jesus, who must be broken for the world to be filled with the aroma and flavor of the gospel.

There is deep truth in the broken leaf of hot tea. I invite you to ponder and wonder about these things as you sit and enjoy your next cup!

8. Tolkien, *The Return of the King*, 155.

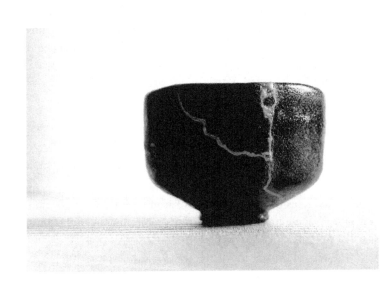

Meditation 2

The Golden Cracks

"Go down to the potter's house, and there I will give you my message." So I went down to the potter's house, and I saw him working at the wheel. But the pot he was shaping from the clay was marred in his hands; so the potter formed it into another pot, shaping it as seemed best to him. Then the word of the Lord came to me. He said, "Can I not do with you, Israel, as this potter does?" declares the Lord. "Like clay in the hand of the potter, so are you in my hand, Israel."

—JEREMIAH 18:2–6

While walking down the corridors of the Kyoto National Museum, I stumbled upon some clay bowls. Everything about the exhibit screamed, "These things are *important*!" They were individually encased behind panes of glass. They sat beautifully displayed on felt-covered small boxes. They each had their own special lighting. The odd thing to me was that they were *broken*.

I mean, usually when something breaks, we throw it out, right? These were just bowls. One does not have to dig too long or too deep in the ancient civilizations of the world to find a fragment

of broken pottery. Pottery is so common, so easily broken, and so easy to replace. So tell me, why did some Japanese artisan take all that time and money to fix these broken bowls, and with gold no less! Who does that? The gold was certainly more valuable than the bowls themselves, and it did nothing to hide the cracks. If anything, it accentuated them, highlighting the broken places. The glory of these bowls was found in their cracks! Somehow, these vessels were *more* beautiful and *more* valuable for having been broken. One bowl in particular stood out to me for a whole piece was completely missing, filled in and sealed with gold.

This was my introduction to the Japanese art of *kintsugi*, and as I gazed at it, I thought, *this . . . THIS is the gospel!*

We are broken in our sin. Our world is broken by sin. Yet God does not just throw us out, but rather renews, repairs, restores, redeems, and reforms. God reforms with the gold of heaven, which never tarnishes or rusts. God, our *Jehovah-Rapha*, the Lord our Healer,[1] displays the life and death of Jesus in our fragile bodies to reveal the golden glory of God. God takes our "incurable" wounds and "injury beyond healing"[2] and works to restore us to complete and perfect health.

Kintsugi displays the gospel, where the glory of God can be revealed in fragile and broken vessels. The glory of our lives and bodies, our value and our beauty, come from Christ displayed in our weakness—*in our cracks*. Paul wrote,

> "We have this treasure in jars of clay to show that this all-surpassing power is from God and not from us. We are hard pressed on every side, but not crushed; perplexed, but not in despair; persecuted, but not abandoned; struck down, but not destroyed. We always carry around in our

1. "[The Lord] said, 'If you listen carefully to the Lord your God and do what is right in his eyes, if you pay attention to his commands and keep all his decrees, I will not bring on you any of the diseases I brought on the Egyptians, for I am the Lord, who heals you.'" (Exodus 15:26)

2. "'Your wound is incurable, your injury beyond healing . . . no remedy for your sore, no healing for you . . . Why do you cry out over your wound, your pain that has no cure? . . . But I will restore you to health and heal your wounds,' declares the Lord." (Jeremiah 30:12–13, 15, 17)

body the death of Jesus, so that the life of Jesus may also be revealed in our body." (2 Corinthians 4:7–10)[3]

Ultimately, *kintsugi* is not about us but about Christ. We carry around in our body both the death of Jesus, through the cracks, and the life of Jesus, through the gold. Our gaps are gold; our cracks are glory. What a completely redemptive view of suffering!

"God has chosen to make known among the Gentiles the glorious riches of this mystery, which is Christ in you, the hope of glory." (Colossians 1:27)

A little earlier, Paul writes, "In [Christ] all things were created . . . and in [Christ] all things hold together" (Colossians 1:16–17). We do not need to, nor can we, 'pull ourselves together.' Christ pulls us together. Christ holds us together with the glorious riches of the golden cracks of heaven, and he makes us stronger than we were before.

One book on *kintsugi* lists eleven types of brokenness that can be found in a bowl.[4] The *kintsugi* artisan trains the eye to not only distinguish between various kinds of brokenness but also to see how to bring beauty out of them. There are many kinds of brokenness in our lives but many more ways God can bring beauty out of them. The Lord God called, "Where are you?" (Genesis 3:9) to Adam and Eve, two people trying to hide brokenness and shame, but God went directly to their brokenness to begin his work there. God crafts our stories in such a way that we will be more beautiful because of our broken pieces.

Once after sharing this illustration with a group of people, a woman came up to talk with me. She had tears in her eyes as she told me, "I'm like that bowl . . . I'm broken. I'm a mess, and there's a huge chunk of my life missing." She went on to share how her

3. My wife and I had an opportunity to visit ancient Corinth, where we learned about that city's fame for technological developments in pottery. One of those advancements was the development of black figures, allowing for more expressiveness and storytelling in pottery. When the Apostle Paul wrote about the gospel using jars of clay, he was communicating from a particularly Corinthian perspective.

4. Nakamura, *Kintsugi Handbook*, 26–27.

husband had passed away the previous year, and a piece of her was missing that could never be replaced. And yet, in that moment, she saw how Christ fills our holes and gaps. Christ turns our eyes away from our suffering and toward his own suffering for us.

Kintsugi makes me think of the slain Lamb of God, in the very center of heaven itself, infinitely valuable and infinitely beautiful, for all of creation to gaze upon.[5] In fact, I am convinced that in the pottery of heaven we will find *kintsugi*, forever reminding us and leading us in eternal praise of the beautiful slain Lamb of God.

5. Revelation 5:2–14

Meditation 3

Sap of the Cross

We boast in the hope of the glory of God. Not only so, but we also glory in our sufferings, because we know that suffering produces perseverance; perseverance, character; and character, hope.

—ROMANS 5:2-4

Have you ever seen those glossy little bowls known as *urushi*? Usually red or black, these quintessential Japanese items can be found in almost any Japanese restaurant or home.

In most cases nowadays, they are but cheap plastic imitations of the real thing, but true *urushi* comes from the *urushi* tree. When the artisan cuts the tree, sap oozes out to make a hard coating on the wound that both protects and strengthens it. Before the sap hardens, it must be collected, mixed with minerals to make it black or red, painted onto the bowl or other wooden utensil, and allowed to dry.

The artist repeats this process—10, 20, 30 or more times—to cover the bowl with thicker and thicker layers of protection. From start to finish, it consumes an enormous amount of time, many months, to allow for the bowl to dry between each and every layer. In the end, gold, shell, or other items can be pressed into the 'wet' *urushi* for decoration.

The *urushi* artist literally dramatizes the story of Christ's sacrifice in every single bowl made. The stripes in the tree make me think of the words of Isaiah when he says, "with his stripes we are healed" (Isaiah 53:5 KJV). The healing sap poured out to cover and protect many bowls makes me think of the words of Jesus when he says, "This is my blood . . . poured out for many" (Matthew 26:28). The ability of these wooden bowls to withstand moisture, temperature, and damage, when they were previously so weak and fragile, quickly mildewing in the humid Japanese climate, makes me think of the words of Paul when he says, "I boast in my weakness, that Christ's power may rest on me" (2 Corinthians 12:9).

God continually paints us with layer after layer of his grace so that Christ's power may cover us, shelter us, and protect us. The blood of the Lamb enters into our wounds and suffering, heals our sin, and transforms our weakness into strength and our ugly sin into beauty. This is the mystery of the gospel! Christ's weakness is our strength. Christ's gaping wounds are our beauty. The sap of the cross transforms us more and more into the likeness of Christ with every successive layer. Only the 'urushi sap' of the cross can heal our wounds and bind our brokenness. *Urushi* as an art form again makes me think about the broken Christ on a broken tree for a broken world.

My favorite kind of *urushi*, called *negoro*, reenacts the gospel drama in the hands of each who choose to use the bowl. In *negoro*, the whole bowl is painted black and then covered with just one thin layer of red. Through normal wear and tear, and even cracks and damage, the red outer layer begins to wear through and the black layers underneath begin to show. The more used and worn out that bowl is, the more beautiful and valuable it becomes.

Negoro, too, reflects the mystery of the gospel. In the time of Moses, priestly garments were designed to reflect the glory and beauty of God. They were carefully woven, cut, stitched, and embroidered by the highest skilled artisans in all of Israel. Their beauty must have been staggering in their perfection! But then God ordered them to be stained with blood and oil.

> "Take some blood from the altar and some of the anointing oil and sprinkle it on Aaron and his garments and on

his sons and their garments. Then he and his sons and their garments will be consecrated." (Exodus 29:21)

Through successive generations and layer after layer of stains, these garments were never to be washed. God delighted in the beauty of these clothes, not in spite of the stains and blemishes, but because of them and through them!

The redemptive analogies of *negoro* and *urushi* also remind me of the tree sap in Gilead widely coveted in Old Testament times for its healing properties. This balm in Gilead pointed to a greater balm, the only medicine that could heal the people of Israel.

"Is there no balm in Gilead? Is there no physician there? Why then is there no healing for the wound of my people?" (Jeremiah 8:22)

Slaves in the United States recognized the promise of this balm in Gilead to bring divine healing to all people and yearned for it through one of the most beloved of spiritual songs.

There is a balm in Gilead,
To make the wounded whole;
There is a balm in Gilead,
To heal the sin-sick soul.

Urushi in all their craftsmanship may be beautiful, but how much more beautiful are we, when we are covered in the glorious blood of the Lamb? *Urushi* may cost hundreds of dollars, but how much more valuable are we when we are covered by the priceless blood of the Son of God? *Urushi* may take a long time to make, but how much more time does it take to paint this broken and sinful world with his grace, preparing us for the kingdom of heaven through all of human history? This gospel story is written and directed by the very One whose sanctifying grace works so abundantly in our lives.[1]

It amazes me that something so common in Japan can be such a daily witness of the gospel. Next time you see one of these little bowls, I urge you to think about Jesus and the healing grace he paints on us through the power of his poured-out blood on the cross.

1. See also Genesis 37:25, 43:11; Ezekiel 27:17; Jeremiah 46:11.

Meditation 4

Rough Patches

Finally, brothers and sisters, whatever is true, whatever is noble, whatever is right, whatever is pure, whatever is lovely, whatever is admirable—if anything is excellent or praiseworthy—think about such things.

—PHILIPPIANS 4:8

As the Apostle Paul urged the people of Philippi, seeing the world through God's eyes is a conscious choice to find what is true and good and beautiful and to meditate on those things. Because we live in a broken world, this choice often involves looking for what is beautiful in the midst of brokenness and weakness.

When Sen no Rikyu worked with tea, he chose broken vessels instead of whole ones. When that first *kintsugi* artist created his art, he chose to fix broken pottery rather than throw them out. When that first *negoro* artist covered a bowl with one thin layer of red, he embraced beauty in the wear and tear of this world. The beauty we make of the stuff of this world reflects that same beauty we see God recreating and remaking in this world—beauty born out of weakness.

One day, Tomihiro Hoshino, a gymnastics teacher just out of college, was demonstrating a double somersault to a group of junior high students when something went tragically wrong. He broke his neck and became paralyzed from the neck down. In the prime of his life, Hoshino found himself confined to a bed and a wheelchair for the rest of his life.

As the years passed, Hoshino accepted his condition and began to see the world differently. He began to understand that his confinement graciously gave him the power of new sight. He began to see the world through the perspective of weakness rather than strength, and with a paintbrush in his mouth (!), he began to communicate that through painting and poetry. His common theme was the fragile beauty of flowers and the seemingly unimportant things of this world.

In one of his books,[1] Hoshino tells the story of riding his electric wheelchair over rough patches on sidewalks and streets. This was both uncomfortable and scary, because there was always the danger that he would fall and lie helpless on the ground. Then a friend gave him a gift, a little bell to attach to his wheelchair. Whenever the wheelchair shook, the bell made what he described as a "crystal-clear sound" that went straight to his heart. Hoshino actually began to enjoy those 'rough patches' that made his little bell sing with such a beautiful and cheery song. "Everyone is given something like this little bell in their mind!" he wrote. "The bell makes no sound when we are going along a smooth road, but when we come to an obstacle or uneven patch in our lives, the little bell tinkles clearly."

Hoshino's story makes me think of the Japanese custom of repairing tears in traditional doors and windows made from fragile *shoji* paper. Swatches of paper are glued over holes to prevent spreading. Rather than plain rectangular pieces, they are sometimes cut into the shape of flowers or other pretty objects. In this way, *shoji* repair becomes a deliberate act of making beauty in the torn places.

1. Hoshino, *Road of the Tinkling Bell*, 90–91.

Beauty in weakness echoes the free and unmerited favor of God poured out on weak people. God redeems his people from destruction by gently remaking them and his world into something beautiful. Grace given by God comes in fragility, a baby born in a barn and a man dying on a cross, too exhausted to even take another breath. When we look to Jesus in his weakness, we receive sight in spite of our weakness to find "whatever is lovely [and] whatever is admirable" (Philippians 4:8). Through Jesus, we can joyfully embrace this kind of beauty in our world.

Meditation 5

Welcome to heaven . . .
Here's your koto!

*I heard a sound from heaven like the roar of rushing waters
and like a loud peal of thunder. The sound I heard was like
that of harpists playing their harps.*

—REVELATION 14:2

The Far Side, one of America's most beloved cartoons, shows a line
of people waiting to go through the gates of heaven. The heading
reads, "Welcome to heaven . . . Here's your harp. Welcome to hell
. . . Here's your accordion."

I am not sure what anyone has against the accordion, but the
Western harp has always been associated with the music of heaven.
Standing vertically, the instrument sends our eyes upward. Glissan-
dos flow effortlessly up and down the strings with no unpleasant
'wrong' notes to pain the ear. Undampened strings, plucked with
the fleshy part of the fingers, bring forth mellow tones.

These angelic melodies have been a source of healing and
comfort since ancient times, even easing the troubled mind of King
Saul.

"When the evil spirit from God was upon Saul, David took an harp, and played with his hand: so Saul was refreshed, and was well, and the evil spirit departed from him." (1 Samuel 16:23 KJV)

The *koto* or Japanese harp provides us with a fascinating contrast, for it seems to embody an earthbound heaviness. The strings are pressed harshly downward with picks, bringing out strident tones, and sounds emanate from the instrument toward the ground. Strings are pushed and pulled, bending the pitch upward and downward, suggesting weeping and sighing. Chords are almost always broken into arpeggios.

Heaviness in the Japanese arts can also be found in traditional *buyō* dancing. Body weight is kept low, knees are bent, and feet are shuffled noisily. Stomping reverberates with low tones through the specially-made hollow stage floor. What a contrast to Western ballerinas who stand on their toes in pointe shoes to give illusions of weightlessness! Ballerinas hold their arms high, cross the stage on the shoulders of others, and leap into the air with feathery lightness.

The most striking difference between Western and Japanese harps is found in the notes themselves. Four of the five notes in the traditional Japanese scale are only a half-step apart, the most dissonant interval in music. Dissonance, in the language of music, is often seen as a form of brokenness.

Yet the Japanese harp sings so clearly of the beauty of redemption!

Kanzo Uchimura, a famous Japanese pastor from the early 1900s, wrote, "With a single touch of the exquisite sound of heaven, the *koto* strings of my heart reverberate."[1] Uchimura's heart resonated deeply with the *koto* not just because of its beauty but because of how it expressed something deep within the human heart.

"I have great heaviness and continual sorrow in my heart." (Romans 9:2 KJV)

We live in a world full of pain, sickness, and death. We know what it means for the strings of our heart to be pressed downward. We experience this dissonance each and every day.

1. Uchimura, "How to Achieve Great Literature."

The music of the *koto* speaks to me of grace amidst the harsh realities of this world, for the beauty of the *koto* is brought out through the melancholy of the *koto*. The Man of Sorrows redeemed our "heaviness" by carrying the heaviness of the cross. Jesus took the path of disintegration to give us a path of integration. Jesus suffered sadness that we might have joy.

The music of the harp is not just the music of earth but also the music of heaven itself.

> "I heard a sound from heaven . . . The sound I heard was like that of harpists playing their harps." (Revelation 14:2)

Could it be that the harps heard in heaven were the sounds of the Japanese *koto*? What if the brokenness of Christ on the cross is eternally celebrated through the 'brokenness' of the music of heaven?

By Jesus' stripes, we are healed. By Jesus' heavy footsteps on Golgotha, our spirits can soar. Perhaps, after all, nothing expresses God's redemptive plan for creation better. As I meditate on these things, I am convinced that there is no music more fitting to greet and welcome us into the kingdom of heaven than the beautiful sounds of this traditional Japanese art.

Our Gaze Is Submarine (2013)
Jacob Rowan

Meditation 6

The Rainbow Bridge

I have set my bow in the cloud, and it shall be a sign of the covenant between me and the earth.

—GENESIS 9:13 ESV

The way I see it, if you want the rainbow, you gotta put up with the rain!

—DOLLY PARTON, AMERICAN COUNTRY SINGER

From the window of my apartment, I can see one of Tokyo's most famous landmarks, the Rainbow Bridge. This huge suspension bridge crosses the bay to connect downtown Tokyo with the man-made island of Odaiba, lighting up the night sky with all the colors of the rainbow.

The Rainbow Bridge received its name from the famous bridge of Japanese mythology, when the gods Izanagi and Izanami created the nation of Japan. While standing on the Floating Bridge of Heaven, a seven-hued rainbow that joins heaven and earth, they looked down on the waters of the immense ocean. Izanagi thrust

his precious stone-covered spear into the chaos and stirred. As he withdrew, large droplets fell to form the first island of Japan.[1]

I find this story fascinating on so many levels! First, think about the nature of a rainbow. When light enters a water droplet, it literally bends and breaks into a million pieces. For us to see the brilliant colors of the rainbow, the light must be broken. *Rainbows too form from brokenness!*

From a biblical perspective, the rainbow also signifies God's covenant with mankind.[2] God made a 'bridge' between heaven and earth in the shape of a rainbow as a visual reminder of his salvation, where brokenness is transformed into glorious beauty. Mankind need no longer pay for sin with devastation and separation from God.

The rainbow is both a sign of the covenant and a display of the covenant 'signed,' written boldly in the blood of Jesus. It is as if the word 'BROKEN' is set in large letters across the sky to proclaim God's salvation to every successive generation and remind us of his love. Broken pieces of tile and stone in mosaics on the walls and floors of church buildings also remind us of this promise, and broken light from the broken glass of stained glass windows floods the interior with color.

"The Son is the radiance of God's glory." (Hebrews 1:3)

The glory of God is found in the face of Jesus Christ, glorified as the crucified Christ, the slain Lamb, the suffering Servant, and the scarred Savior. God the Father reveals his glory to us with a broken-become-beautiful glory of the seven-hued light of the rainbow.[3]

1. This story is told in the opening pages of the *Kojiki: A Record of Ancient Matters*, the oldest existing collection of myths, legends, and historical accounts of ancient Japan, compiled from oral tradition in 712 AD.

2. "I have set my bow in the cloud, and it shall be a sign of the covenant between me and the earth. When I bring clouds over the earth and the bow is seen in the clouds, I will remember my covenant that is between me and you and every living creature of all flesh. And the waters shall never again become a flood to destroy all flesh." (Genesis 9:13–15, ESV)

3. On Day 1, the same day that God created the heavens and the earth, God created light. When Jesus appeared to Saul on the road to Damascus, Saul saw

"Like the appearance of a rainbow in the clouds on a rainy day, so was the radiance around him. This was the appearance of the likeness of the glory of the Lord." (Ezekiel 1:28)[4]

The rainbow points to Christ as the glory of God but so too does the bridge. One night Jacob had a dream that angels would ascend and descend a stairway that acted as a bridge between heaven and earth. This bridge was not possible for him to walk or climb. Jesus did not come to show the way over the bridge. Jesus came to *be* that bridge so that God himself would cross and be with men.

"Very truly I tell you, you will see 'heaven open, and the angels of God ascending and descending on' the Son of Man." (John 1:51)

The Son of Man is not a bridge to God but a bridge on God. Angels do not ascend or descend 'to' or 'from' the Son of Man but 'on' the Son of Man. Jesus is that narrow bridge that cannot be crossed through any human skill or merit. Jesus is the path of brokenness, gloriously displaying God's gospel plan for creation.[5] Every time I see the Rainbow Bridge out my window, I remember Christ, that beautiful broken bridge connecting heaven and earth.

a heavenly light. Light reflects the glory of God and his kingdom. Just as the light of the sun, moon, and stars point to his glory so too does the radiance of the rainbow.

4. See also Revelation 4:3, "A rainbow that shone like an emerald encircled the throne," and Revelation 10:1, "He was robed in a cloud, with a rainbow above his head; his face was like the sun, and his legs were like fiery pillars."

5. Sally Lloyd-Jones gives yet another fascinating view of the significance of the rainbow. In the original Hebrew for Noah's story, the word "bow," as in bow and arrow, is used instead of rainbow. "Like a warrior who puts away his bow and arrow at the end of a great battle, God said, 'See, I have hung up my bow in the clouds.' And there, in the clouds—just where the storm meets the sun—was a beautiful bow made of light. It was a new beginning in God's world . . . before the beginning of time, he had another plan—a better plan. A plan not to destroy the world, but to rescue it—a plan to one day send his own Son, the Rescuer. God's strong anger against hate and sadness and death would come down once more—but not on his people, or his world. No, God's war bow was not pointing down at his people. It was pointing up, into the heart of heaven." Lloyd-Jones, *The Jesus Storybook Bible*, 46–47.

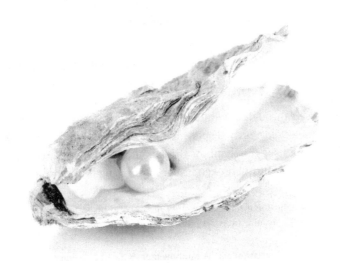

Meditation 7

Pearls and the People of God [1]

The kingdom of heaven is like a merchant looking for fine pearls. When he found one of great value, he went away and sold everything he had and bought it.

—MATTHEW 13:45-46

Of all the gems, minerals, and precious metals of the world, nothing compares with the iridescent glow of *Akoya* pearls. With no cutting, chipping, or polishing needed to bring out their natural beauty, these "perfectly shaped spheres" (真珠) are incredibly valuable, and, according to Thomas Edison, an apparent "biological impossibility." [2]

1. This chapter first appeared in Lowther, "Pearls and the People of God," 30–31. Used with permission.

2. At the Mikimoto Pearl Island Museum in Toba, Japan, there is a letter from Thomas Edison to Kokichi Mikimoto. During their visit together, Edison said while examining a pearl, "This isn't a cultured pearl, it's a real pearl. There are two things which couldn't be made at my laboratory—diamonds and pearls. It is one of the wonders of the world that you were able to culture pearls. It is something which is supposed to be biologically impossible." Mikimoto is said to have responded, "If you were the moon of the world of inventors, I would simply be one of the many tiny stars."

Pearls embody an important part of Japanese history and culture. The "Pearl King" Kokichi Mikimoto (1858–1954) almost single-handedly created the cultured pearl industry, at one point producing seventy-five percent of the world's market. His pearls supplied the high-end jewelry market with necklaces and earrings, bringing great fame to his flagship store and namesake Mikimoto in Ginza, just a short jog from where I live. Soon others copied his techniques and freshwater *Biwa* pearls farmed in Lake Biwa became nearly synonymous with freshwater pearls worldwide.

The birth of pearls is truly a miraculous event. *Pearls form from brokenness.*

When something damages cells in the mantle—a piece of sand, shell, bacteria, or parasite—the shellfish responds by coating it with protective layers.[3] In cultured pearls, this irritant is surgically inserted into the weakest and most fragile area of the shellfish (its gonads) along with a small piece of mantle from another shellfish sacrificed in the process. Over time, thousands upon thousands of fine layers of nacre create a shiny translucent ball lighter and stronger than concrete.[4]

Shellfish that have been damaged create these incredibly beautiful and valuable objects. How fascinating, then, that pearls formed from brokenness and suffering symbolize the perfection of the kingdom of heaven, for no one can enter the celestial city without first walking through its "pearly gates"!

> "The twelve gates were twelve pearls, each gate made of a single pearl." (Revelation 21:21)

What if God created shellfish to perpetually reenact the gospel story? Jesus, like the shellfish, was cut that we may be coated with layer after layer of God's grace, changed from objects of wrath into objects of mercy.[5] The suffering of the Lamb *literally* created a

3. The museum and staff at Mikimoto Pearl Island in Toba, outside of Nagoya, greatly helped me understand the process of making pearls.

4. Also known as mother-of-pearl, nacre consists of a mixture of calcium carbonate and organic proteins.

5. "What if God, although choosing to show his wrath and make his power known, bore with great patience the objects of his wrath—prepared

gateway for us to enter the kingdom of heaven, and through pearls, we see God's people displayed and glorified in weakness while eternally covered in the beauty of God.

There are other pointers of brokenness surrounding the heavenly city.

> "[The angel] measured the city with the rod and found it to be 12,000 stadia in length, and as wide and high as it is long. The angel measured the wall using human measurement, and it was 144 cubits thick. The wall was made of jasper." (Revelation 21:16–18)

The walls of heaven too are made from brokenness. Jasper forms under incredible heat and pressure deep underground, where layers of sediment, dust, and ash fracture, bend, and break. The beauty of jasper lies in the marks and scars of its affliction. Its glory lies in the visible display of its transformed brokenness.

Consider too the foundations made from twelve gemstones.

> "The foundations of the city walls were decorated with every kind of precious stone. The first foundation was jasper, the second sapphire, the third agate, the fourth emerald, the fifth onyx, the sixth ruby, the seventh chrysolite, the eighth beryl, the ninth topaz, the tenth turquoise, the eleventh jacinth, and the twelfth amethyst." (Revelation 21:19–20)

What this list tells us is the very nature of the foundations of the city. When dug from the ground, gemstones are nothing but plain dull rocks. Only through careful cutting, grinding, and polishing in the hands of an artist can light make these precious stones sparkle with gloriously rich colors. God delights to bring the beauty of gemstones out of broken pieces.

Like the twelve gates and twelve foundations, the people of God are represented in the measurements of the walls of heaven, twelve by 1,000 stadia in length and height and twelve by twelve cubits in thickness. We, the people of God, form the very gates,

for destruction? What if he did this to make the riches of his glory known to the objects of his mercy, whom he prepared in advance for glory—even us?" (Romans 9:22–24)

foundations, and walls of heaven. We are the Holy City, the bride of Christ, eternally pointing to and displaying the glory of God through the gospel of Christ.

> "'Come, I will show you the bride, the wife of the Lamb.' And he carried me away in the Spirit to a mountain great and high, and showed me the Holy City, Jerusalem, coming down out of heaven from God. It shone with the glory of God." (Revelation 21:9–11)

Through the pearly gates and the city of heaven, we not only see the final product of the gospel, but we also catch a small glimpse of our own beauty and worth in the eyes of God.

> "The kingdom of heaven is like a merchant looking for fine pearls. When he found one of great value, he went away and sold everything he had and bought it." (Matthew 13:45–46)

Do we dare imagine that we could be that pearl of great price? Is it possible that Christ gave up everything he had to purchase *us*? Can we imagine that pain and suffering can be redeemed as the building blocks of heaven itself?

> "With your blood you purchased for God persons from every tribe and language and people and nation." (Revelation 5:9)

The pearls of heaven were purchased by the very blood of the Merchant. The crowning beauty of heaven can be found in the Lamb who was slain, lying on the glorious throne of God. Rainbow light forever encircles this throne, literally bending and breaking the white light for the sake of his glory. The iridescence of pearls, caused by a kind of rainbow effect,[6] is yet one more reflection of *his* broken beauty!

6. This rainbow effect occurs because the thickness of the microscopically thin layers is similar to the wavelength of light, causing interference and diffraction. The goddess Iris of Greek mythology, from whom the English language gets the word iridescence, is the personification of the rainbow and a messenger of the gods.

The more we recognize our own brokenness and the mercy God graciously surrounds us with, the more richly we can worship Christ and engage the broken and suffering in this world. Pearls give a picture not only of how this world will one day be redeemed into a thing of great beauty but also of how we are more cherished in the eyes of God than we could possibly hope or imagine. Pearls, "the queen of gems and the gem of queens," perhaps best symbolize the bride of Christ and the people of God.

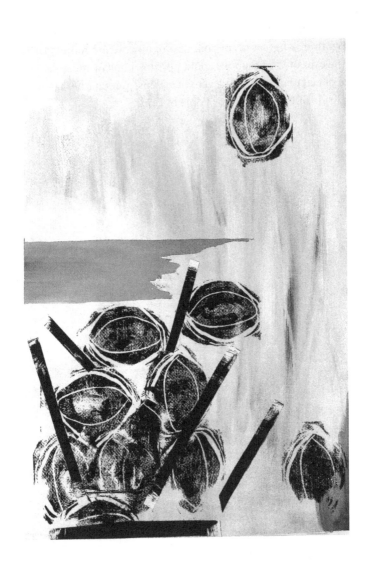

The Loved Ones—Part 2 (2018)
Brandy Antonio

Meditation 8

The Forsaken One

*On the day you were born your cord was not cut, nor were you
washed with water to make you clean, nor were you rubbed
with salt or wrapped in cloths. No one looked on you with pity
or had compassion enough to do any of these things for you.
Rather, you were thrown out into the open field, for on the day
you were born you were despised. Then I passed by and saw
you kicking about in your blood, and as you lay there in your
blood I said to you, "Live!"*

—EZEKIEL 16:4–6

Ezekiel 16 has always been one of my favorite passages of the Bible.
Nowhere else is God's heartfelt sentiment toward his people made
so abundantly clear. God looks straight at us in a helpless state of
misery, loved by no one, and boldly says, even shouts, "Live!"

 While reading the novel *Coin Locker Babies* by Ryu Murakami,
I was struck by how deeply the story takes the reader into a world
devoid of this kind of love. The story begins on a hot summer day,
when two mothers abandon their newborn baby boys in coin lock-
ers in Tokyo Train Station. Only a cry heard by a chance passerby

happens to save the boys, who are brought to an orphanage and eventually adopted and raised as brothers.

As the two grow up, they spend their lives searching in all the wrong places for love, symbolized by the comfort and sense of belonging they knew in their mothers' wombs. The novel begins with despondency and ends with rage, the impulse for destruction, and yet an insatiable desire for life.

> "The message that the heartbeat carried to the child within was one that never changed. He drew another breath, feeling it refresh his lips, and then a sound emerged—the cry of a newborn baby. Never, he told himself, will I forget what my mother's heart was telling me. Live! it said. You shall not die. Live! Yes, live! Each beat drummed out the message, imprinting it on my muscles, and veins, and on my voice."[1]

"Live!" is the first message every human feels in the mother's womb. The steady heartbeat of a creature bigger than ourselves gives us our first sensations of love, intimacy, hope, and protection. And what an image it is!

Coin Locker Babies is full of darkness, to such extremes that I find it hard to recommend to most audiences, but without a doubt Murakami's imagery and storytelling powerfully capture the lie that waits in the shadows of each and every human heart. We are unloved. We are unwanted. We are alone.

> "Suddenly, [Hashi] was overwhelmed by all the sadness in the world, by the thought that there was no such thing as happiness, and as he struggled to keep from weeping, his mood slowly changed, gradually becoming more like rage."[2]

The Bible tells an entirely different story.

> "Can a mother forget the baby at her breast and have no compassion on the child she has borne? Though she may forget, I will not forget you!" (Isaiah 49:15)

1. Murakami, *Coin Locker Babies*, 392–93.
2. Ibid, 152.

Jesus knows the pain of abandonment. On the cross, he not only lost his friends and family, but he also lost the love of the Father which he had known for all eternity. On the cross, Jesus cried out those unforgettable words of abandonment.

"My God, my God, why have you forsaken me?" (Matthew 27:46)

In the Japanese, the words are literally, "Why have you thrown me away?" On the cross, Christ experienced total physical and emotional abandonment so that we would never have to know that kind of abandonment. Christ became the forsaken One so that you and I would never have to be the forsaken ones.

"You shall no more be termed Forsaken." (Isaiah 62:4 ESV)

Our loneliness vanishes in light of God's pursuit to rescue us from the dark "coin lockers" of this world. The warmth and comfort of a mother's heartbeat cannot compare with the unending and incomprehensible love of the heavenly Father. Jesus says, "I have come that they may have life, and have it to the full" (John 10:10), and, "I am with you always, to the very end of the age" (Matthew 28:20). He comes to us as *Immanuel*, God with us.

God says to us, "Live!" then repeats it again, "Live!"[3] His message echoes through all of Scripture that we may not miss the urgency of it. We are loved. We are wanted. We will never be truly alone.

3. Most Hebrew manuscripts repeat the proclamation to "Live!" in verse 6 as a way of emphasis. God does not want us to miss his message!

Alignment (2019)
Peter Bakelaar

Meditation 9

Finding the *'Bi'* in Our *'Sanbi'*

Offer your bodies as a living sacrifice, holy and pleasing to God—this is your true and proper worship.

—ROMANS 12:1

The Japanese word for worship is constructed from the character for 'praise,' *san* (賛), and the character for 'beauty,' *bi* (美). Christian worship is all about "praise through the beautiful" and "praise of the beautiful." In order to worship God, we have to find the *'bi'* in our *'sanbi.'*

Many things in this world are beautiful, but the character for beauty in the Japanese language seems to suggest a special kind of beauty that can only come about through brokenness and sacrifice. Dr. Tomonobu Imamichi, a recently deceased professor of aesthetics at Tokyo University, described it this way.

> "In comparing beauty and goodness, I consider beauty to be the more transcendent of the two. The ideogram of "goodness" (善) is made up of two ideograms; one of a sacrificial "sheep" (羊) on top of an ideogram of a "box" (口). To be good, it is only necessary to fulfill predetermined (a "box") sacrifice determined by society:

paying taxes, or participating in traditions, rituals and such. The ideogram of "righteousness" (義) is made up of the ideograms of sacrificial "sheep" (羊) on top of the ideogram of "self" (我). It means to carry the sacrifices yourself. But the ideogram of "beauty" (美) is made up of the sacrificial "sheep" (羊) on top of an ideogram for "great" (大), which I infer to mean "greater sheep." It connotes a greater sacrifice, a sacrifice that cannot be boxed in by ritual or self. This greater sacrifice may require sacrifice of one's own life to save the lives of others. This sacrifice is not enforced by rules nor is it predetermined, but originates from self-initiative, a willing sacrifice. This is what is truly beautiful."[1]

Dr. Imamichi is referring to a transformational beauty we find everywhere in our world, as it is uncovered in the heart of the Japanese language. When the dying leaf falls from the tree and the 'dying' sun falls from the sky, they burst into color. The atom has to break for the sun to give its warmth and light,[2] and the seed has to die for the tree to grow.[3] The *sushi* chef creates a beautiful meal from the life of a fish. The candlestick and stick of incense create light and sweet aroma through burning and disintegration. Wood has to be pulverized to make Japanese paper, and the paper has to be chopped for the lovely art of *kiri-e*. The beauty of *ikebana* flower arranging comes through the cutting of flowers.

The Christian writer Ayako Miura movingly captured true stories of self-sacrifice in many of her novels including her most famous one, *Shiokari Pass*. Masao Nagano threw himself onto the train tracks of a mountain in Hokkaido to stop a passenger car

1. Imamichi, "Poetry and Ideas," 14. Cited in Fujimura, *Silence and Beauty*, 65–66.

2. When King David wrote, "The heavens declare the glory of God" (Psalm 19:1), little did he know that the heavens declare this glory through the literal breaking of atoms!

3. Voskamp, *The Broken Way*, 160. Earlier she writes, "The seed breaks to give us the wheat. The soil breaks to give us the crop, the sky breaks to give us the rain, the wheat breaks to give us the bread. And the bread breaks to give us the feast. There was once even an alabaster jar that broke to give him all the glory" (25).

from careening out of control.[4] The lives of everyone on board were saved, and the story continues to impact all who hear of the tale. Miura's first novel, *Freezing Point*, culminates in the self-sacrifice of missionary A.R. Stone, who drowned in a terrible typhoon in 1954.[5] Instead of saving himself, Stone helped others into life jackets, even giving away the one he was wearing to save the life of a college student.

On my very first trip to Japan, my wife and I were treated to a performance of *kabuki*, a traditional Japanese art combining music, dance, and drama. Walking into that old wooden theater, I had no idea what to expect. The sounds of the *shamisen*, drums, and bells, and the movement of the actors on the stage were new and exotic to me. A translator over a crackling headset told the story in broken English, but all I could catch was that shame had somehow fallen on the city. In the end, a man visibly bore the weight of the shame on his shoulders as he slowly and heavily walked the raised platform from the stage to the back of the theater. When the lights came on, everyone in the theater was weeping and wiping their eyes.

The scene haunted me for years, and it was only recently that I learned the deeper meaning of the story. I found a library dedicated exclusively to *kabuki* within walking distance of my home and described to the librarian as much as I could remember. After she handed me some big old books, I pored over them . . . for hours. Then I found it!

4. Masao Nagano (1880–1909) was a Christian railway employee and former member of Ayako Miura's church in her hometown of Asahikawa in Hokkaido. On his way home from church in the town of Wassamu on the evening of February 28, 1909, the last carriage of the train suddenly became uncoupled on its way up to Shiokari Pass. He pulled the emergency hand brake, but it only slowed the train. As the carriage began to gain speed and would certainly derail at the next bend, he looked back to the other passengers, nodded as if to say farewell, and then threw himself on the tracks saving the lives of everyone on board.

5. Alfred Russell Stone (1895–1954) was taking the Toya Maru ferry from Hakodate to Aomori after a full day of preaching in Sapporo on September 26, 1954, when Typhoon Marie hit northern Japan sinking five ferries (including the Toya Maru) and killing 1,800 people. Due to this disaster, the typhoon is known as the Toya Maru Typhoon.

Sugawara and the Secrets of Calligraphy powerfully retells the true story of Sugawara Michizane, a high court noble who lived in ancient Japan at the end of the ninth century.[6] Due to the actions of his daughter Princess Kariya, shame fell on the family and his entire domain. The only way to save his daughter and the people was to accept exile. Without even the luxury of looking upon the face of his beloved daughter one last time, Michizane took all the shame upon himself and walked through his city gates for the last time.

Surprising to me, this was not the end of the story! *The Village School*, the most famous scene in all of *kabuki*, comes just a little later. After Michizane's death, an evil lord sent men to the school to kill Michizane's only son and heir. Realizing the boy could only be saved through the ultimate sacrifice, a faithful retainer gave the life of his only son to take the place of Michizane's son.

As I read this, I wanted to stand up right there in the middle of the library and shout, "This is it! This is the gospel!" Who would have guessed that dusty old books about historical Japan would be full of such powerful pointers to Christ? I was so emotionally overcome that I walked in a daze all the way back home.

Memories from the 2011 tsunami came flooding back to me, stories of self-sacrifice. The father who told me about his daughter, a school teacher, who kept running toward the sea to gather children from the streets. School had just let out for the day, and she was trying her best to bring them all back to the safety of the school on high ground before the tsunami struck. But the last time, she never came back. I remembered the story of the firemen in Kamaishi who drove up and down the streets looking for people to evacuate until they missed their final chance for escape, and they too were overcome by the wave. I saw the memorial for the young woman in Minami Sanriku who continually sounded the alarm over the town loudspeaker until her voice was at last silenced by the waves. I thought of the 'Fukushima 50' who risked radiation sickness and death to prevent a global disaster from the broken nuclear power plant.

6. Exact dates are 845–903 AD.

Beautiful stories of sacrifice in this world give a dim shadow of the centerpiece of all beauty found in the center of heaven itself.

> "I saw a Lamb, looking as if it had been slain, standing at the center of the throne, encircled by the four living creatures and the elders . . . And they sang a new song, saying: 'You are worthy to take the scroll and to open its seals, because you were slain, and with your blood you purchased for God persons from every tribe and language and people and nation.'" (Revelation 5:6, 9)

Sacrifice is a path of beauty, and the way of sacrifice is the way of the cross. All the sacrifices we see in this world, both large and small, point to the greater self-sacrifice we find in heaven, the "greater Sheep" who was slain.

In the same passage where Isaiah proclaims the beauty of the King, God proclaims he will be exalted and lifted up.[7] The beauty of the King shines forth in his sacrifice on the cross with the sign, "King of the Jews," nailed above his head. The beauty of the King is manifest in his act of being crushed for our shame. The sacrificial beauty of Christ is worshiped through the sacrificial pouring of perfume over his head. "Leave her alone," Jesus said. "Why are you bothering her? She has done a beautiful thing to me" (Mark 14:6).

We cannot praise the glory of God without being overcome by the beauty of God, without finding the 'bi' in our 'sanbi.' How appropriate then that the center of our corporate worship turns out to be communion, the celebration of the people of God through the brokenness of God. The beauty of Christ's sacrifice directly links us to him as the object of our worship.

7. "Your eyes will behold the king in his beauty" (Isaiah 33:17). "Now will I arise," says the Lord. "Now will I be exalted; now will I be lifted up" (Isaiah 33:10).

Waterflame (2012)
Satoko Oikawa

Meditation 10

A Pleasing Aroma

Aaron . . . shall take a censer full of coals of fire from the altar before the Lord, and two handfuls of sweet incense beaten small, and he shall bring it inside the veil and put the incense on the fire before the Lord, that the cloud of the incense may cover the mercy seat that is over the testimony, so that he does not die.

—LEVITICUS 16:11–13 ESV

We use our senses to tell us what is good and pleasing and beautiful about the world, and of all them, scientists say that our sense of smell is by far the strongest. It comes as no surprise, then, that aroma too has been developed in Japan as *kōdō* or "the way of fragrance," one of the three classical arts along with "the way of tea" and "the way of flowers."

The ceremony entails passing around a small bowl containing a hot coal of bamboo placed in a bed of ash and topped with a splinter-sized piece of wood. As it heats up, the oils in the wood emit a subtle aroma. Participants take turns "listening" to the wood and

writing down their impressions. The master of *kōdō* will recognize the subtle differences and correctly identify each and every piece.

My fascination with this art form though lies less in the ceremony itself and more in the unique formation of this special wood.[1] When the Aguilaria tree is wounded and infected by fungi, it emits a resin to protect itself. This resin makes the wood palpably darker and heavier, and one day when the tree dies and rots away, all that is left are veins of those wounds once the heart of the tree. This resulting wood, called Agarwood, is so rare and precious that it can cost over twice its weight in gold!

The value of this tree comes not in spite of but *through* its suffering. The preservation of the wood comes not in spite of but *through* its injury and infection. The sweet aroma releases only through the intense affliction of heat. *The wood becomes beautiful through a kind of breaking.*

The more I think about the *kōdō* ceremony, the more I am led in worship. I am reminded of the aromatic frankincense and myrrh presented to Jesus after his birth and the expensive perfume poured over his head before his death. Christ is that "sweet incense beaten small" (Leviticus 16:12) whose incense cloud covered the mercy seat so that the people did not die in the presence of God. Christ is the one who "loved us and gave himself up for us as a fragrant offering and sacrifice to God" (Ephesians 5:2). Christ's blood is the sap of the cross, shed on the wounded tree, to preserve and beautify *us.*

What a mystery of all mysteries! The affliction of the cross is the beauty of heaven. The suffering of the Christ is a good and pleasing and beautiful aroma to the Lord . . . in *us!*[2]

The *kōdō* ceremony ends with the words, *Kou michimashita* ("You have been filled with fragrance"). May this be our ongoing prayer. May we be filled with the "aroma of Christ"[3] so that the world may be filled with his life-giving aroma. May the brokenness

1. Morita, *The Book of Incense*, 26.

2. In Exodus 29, Aaron and his sons are consecrated by being sprinkled with the blood of the ram on their ears, thumbs, toes, and garments, and the ram is ceremonially burned as a "pleasing aroma" to God.

3. "For we are to God the pleasing aroma of Christ among those who are being saved and those who are perishing" (2 Corinthians 2:15).

of Christ enable us to take the wounds and pain and decay of this world to the foot of the cross for the healing of the nations. For in this way, God works through the brokenness of this world to transform it, and us, into the incomparable beauty and treasure of heaven.

> *Whence is that goodly fragrance flowing,*
> *Stealing our senses all away?*
> *Never the like did come a-blowing,*
> *Shepherds, from flow'ry fields in May.*
> *Whence is that goodly fragrance flowing,*
> *Stealing our senses all away?*[4]

4. "Quelle est cette odeur agréable?" is a traditional seventeenth-century French Christmas carol. This English translation is by Allen Beville Ramsay (1872–1955).

Bibliography

Fujimura, Makoto. *Silence and Beauty: Hidden Faith Born of Suffering.* Downers Grove, IL: InterVarsity Press, 2016.

Fukuda, Mitsuo. *Developing A Contextualized Church As A Bridge To Christianity In Japan.* Gloucester, United Kingdom: Wide Margin, 1993.

Hoshino, Tomihiro. *Road of the Tinkling Bell.* trans. Gavin Bantock and Kyoko Oshima. Tokyo: Kaisei Sha, 1990.

Imamichi, Tomonobu. "Poetry and Ideas." trans. Makoto Fujimura. *Doyo Bijutsu* 2, no. 114, 1994.

Kitamori, Kazoh. *Theology of the Pain of God.* Eugene, OR: Wipf & Stock, 1965.

Lloyd-Jones, Sally. *The Jesus Storybook Bible: Every Story Whispers His Name.* Grand Rapids, MI: Zonderkidz, 2007.

Lowther, Roger W. "Pearls and the People of God." *Japan Harvest,* vol. 70, no. 3, Summer 2019.

Morita, Kiyoko. *The Book of Incense: Enjoying the Traditional Art of Japanese Scents.* Tokyo: Kodansha, 1999.

Murakami, Ryu. *Coin Locker Babies.* trans. Stephen Snyder. Tokyo: Kodansha International, 2002.

Nakamura, Kunio. "金継ぎ手帳: Kintsugi Handbook." Tokyo: Genkosha, 2017.

Takanaka, Masao. *God Is Rice: Asian Culture and Christian Faith.* Eugene, OR: Wipf & Stock, 1986.

Tolkien, J.R.R. *The Return of the King.* New York: Ballantine Books, 1965.

Uchimura, Kanzo. "How to Achieve Great Literature." trans. Christopher Born. *Kokumin no tomo,* no. 265/266, October 12, 1895.

———. "Japanese Christianity." *The Japan Christian Intelligencer.* vol. 1, no. 3, May 15, 1926.

Voskamp, Ann. *The Broken Way.* Grand Rapids, MI: Zondervan, 2016.

Made in the USA
Coppell, TX
18 December 2019